# Dot-to-Dot
# AMAZING ANIMALS

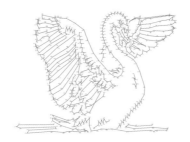

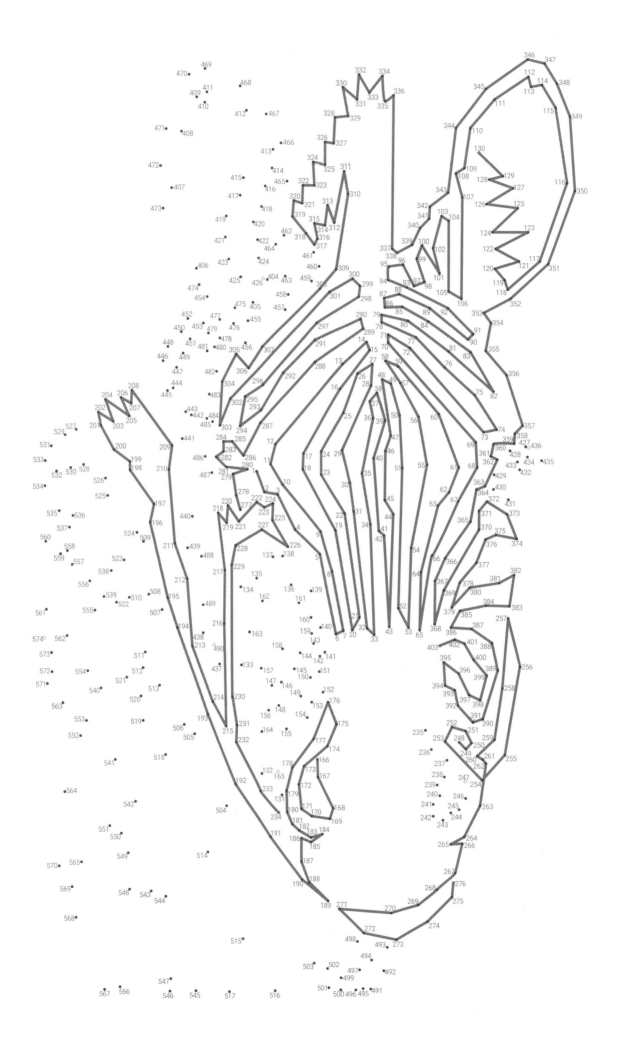

# Dot-to-Dot

# AMAZING ANIMALS

Join the dots to discover the world's best-loved birds and beasts

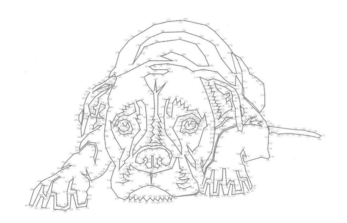

Jeni Child

**southwater**

# Introduction

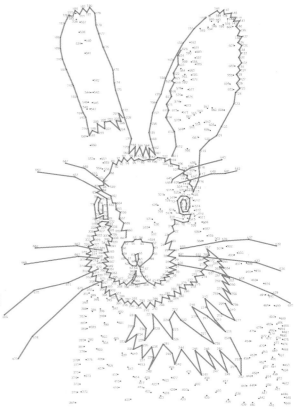

Dot-to-dot puzzles have long been a popular activity for young and old alike, with the opportunity to happily while away the hours uncovering hidden animals, characters, buildings and places. This fabulous new book takes simple join-the-dot art to the next level with 40 puzzles of delightful creatures to complete. Intricate, challenging and rewarding to finish, the puzzles range from 352 to 1020 dots and will have you transfixed as you progress from dot to dot trying to see what image materializes.

An absorbing and relaxing activity that can calm and reduce daily stresses and anxieties, these brain-stimulating puzzles can contribute to alertness. There are also proven educational benefits to doing dot-to-dot activities. It helps to build fine motor skills, improve concentration levels and strengthen mapping skills – all while creating memorable art to enjoy. Each drawing may take approximately half an hour to complete, perfect for a rainy day or holiday activity, or simply a chance to take yourself away for some peace and quiet for a while.

The fabulous animals included here are best-loved species from a wide range of habitats including woodlands, mountains, deep seas, freshwater rivers, steamy jungles, African plains and polar icecaps. They are all wonderful examples of the animal kingdom and have been

closely studied by enthusiastic naturalists. These animals have been captured as dot-to-dot puzzles, their identities waiting patiently to emerge from the depth of the dots to reveal who they are.

As some of the drawings are quite intricate in parts it is best to use a pen (rather than a pencil) with a fine tip. Starting at number 1, connect the dots in numerical order. If a number is next to a circle rather than a dot, lift your pen and start again at the next consecutive number. This number may not necessarily be close to the previous number, it can be anywhere on the design.

Continue completing the picture in this manner, picking up your pen whenever you come to a circle until you have come to the last dot. For the most accurate picture, try to keep a relatively straight line between the connecting dots, but don't worry if you make a mistake or have a wobbly line, it won't affect the finished piece.

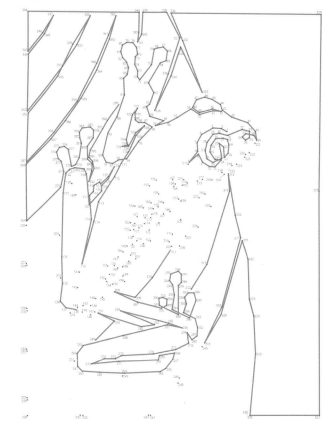

Once you have completed your dot-to-dot artwork, turn to the back of the book where you can compare your work with the finished solution and also read some interesting facts about the animal you have drawn.

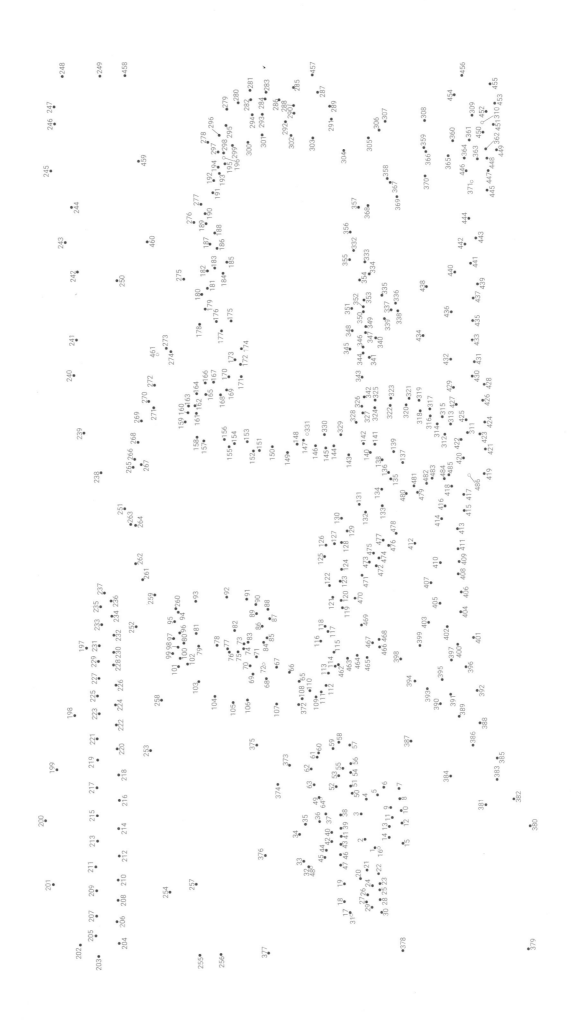

1

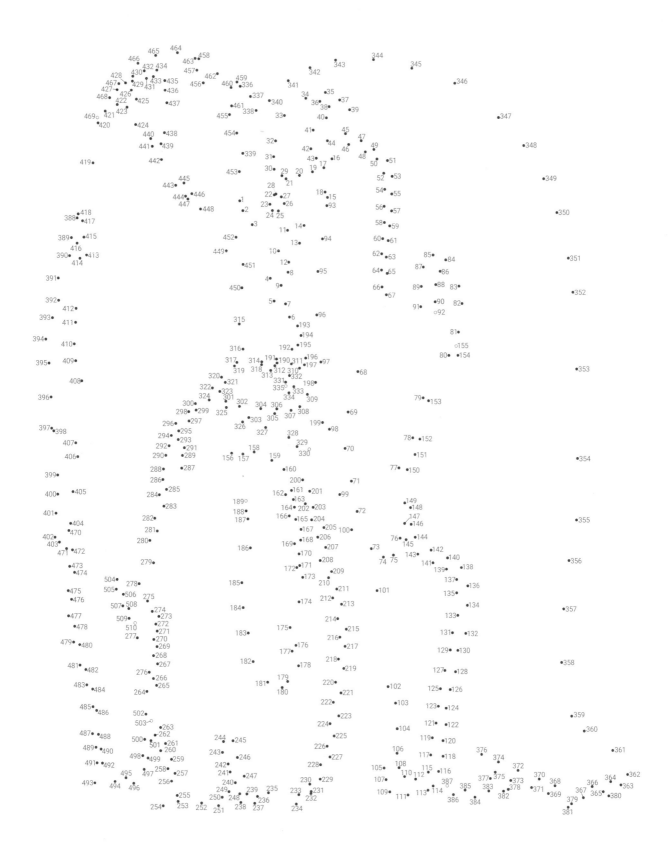

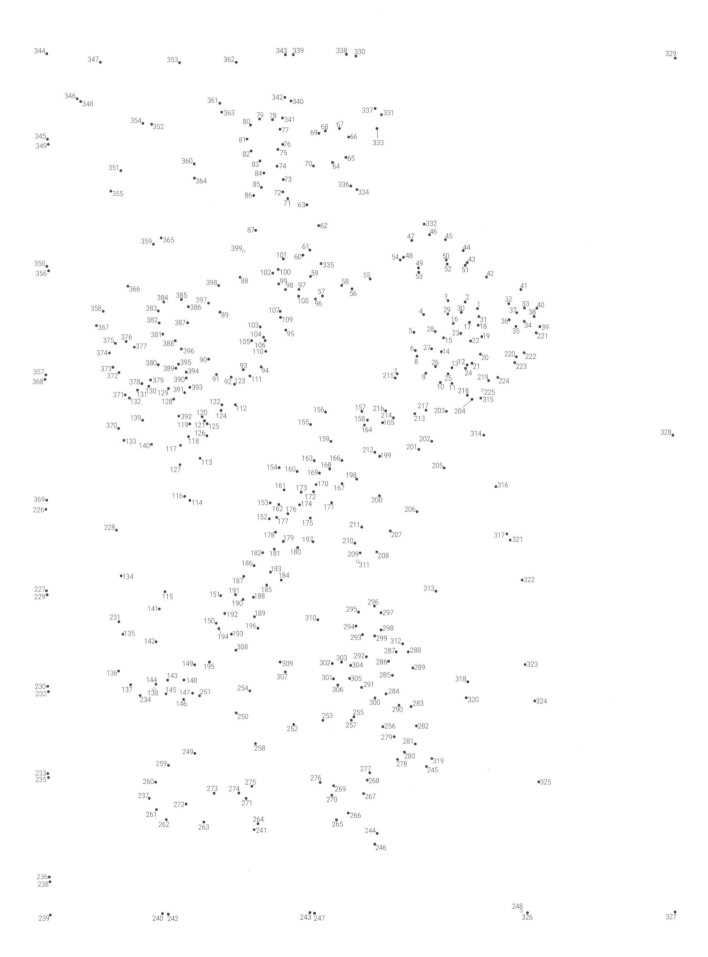

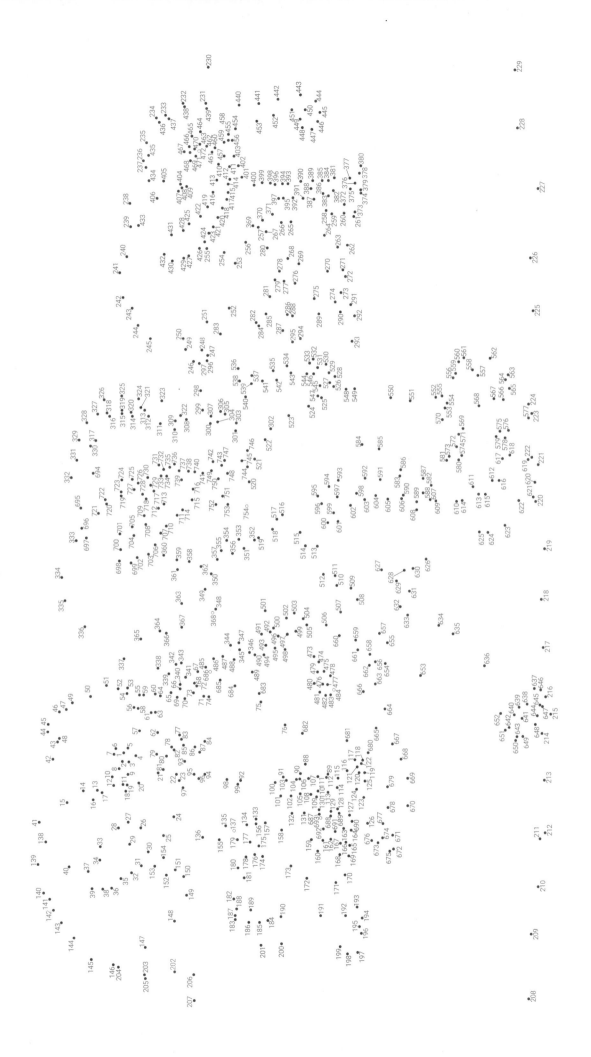

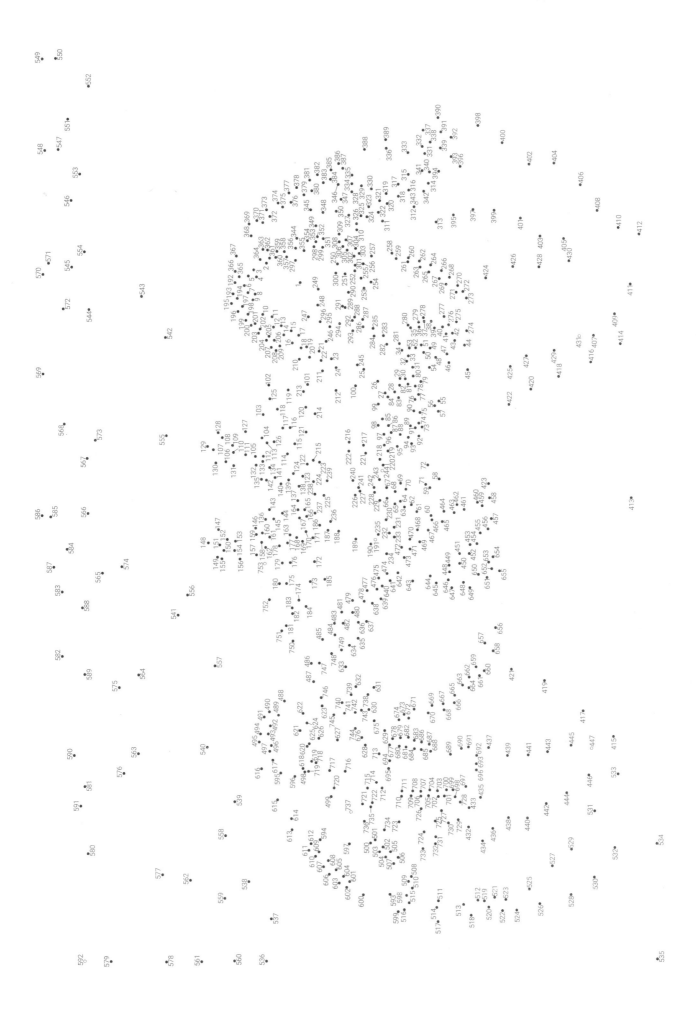

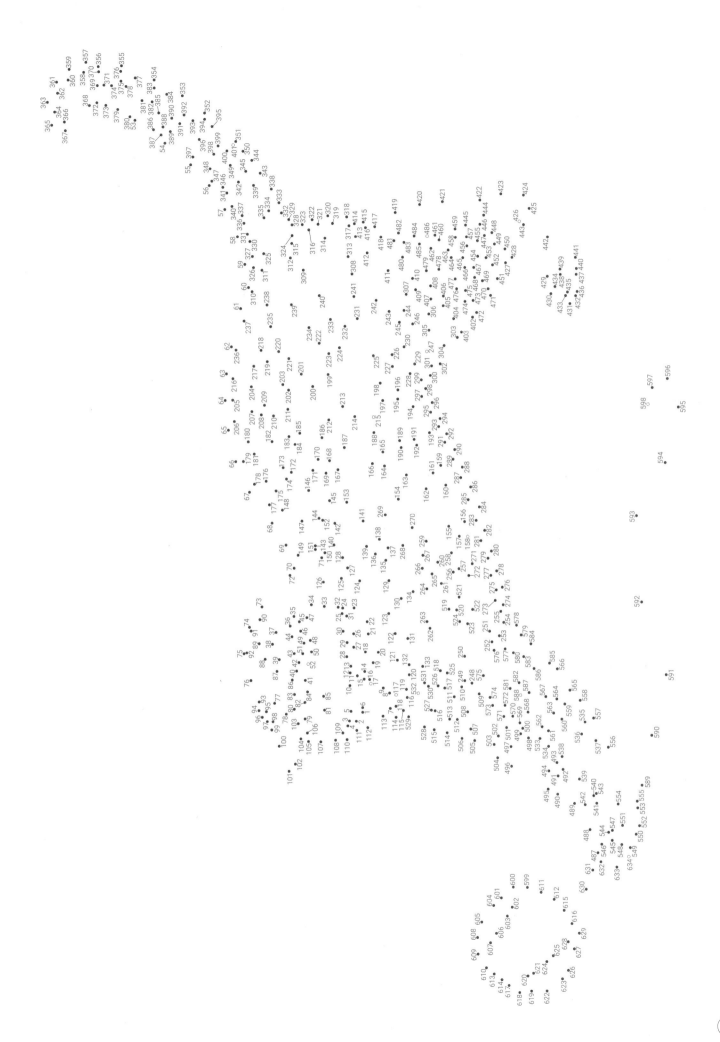

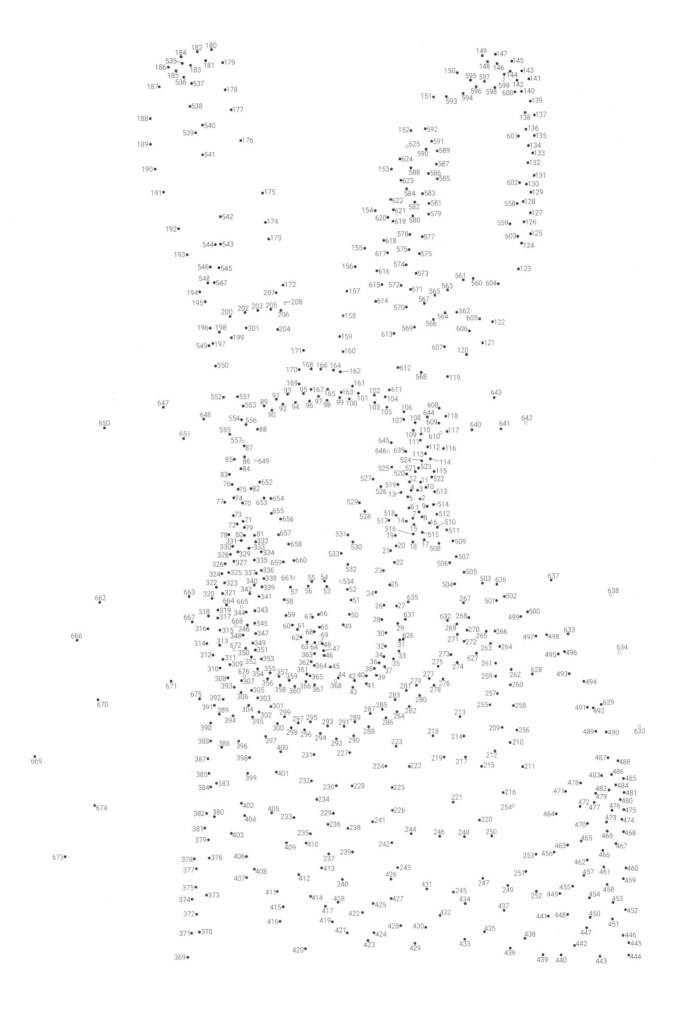

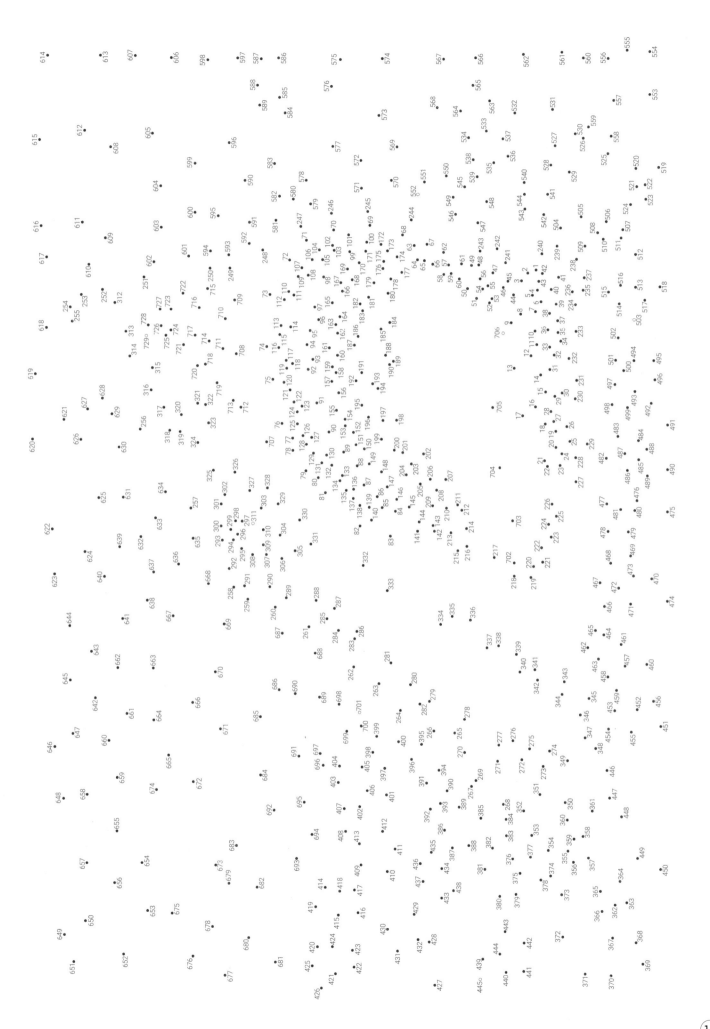

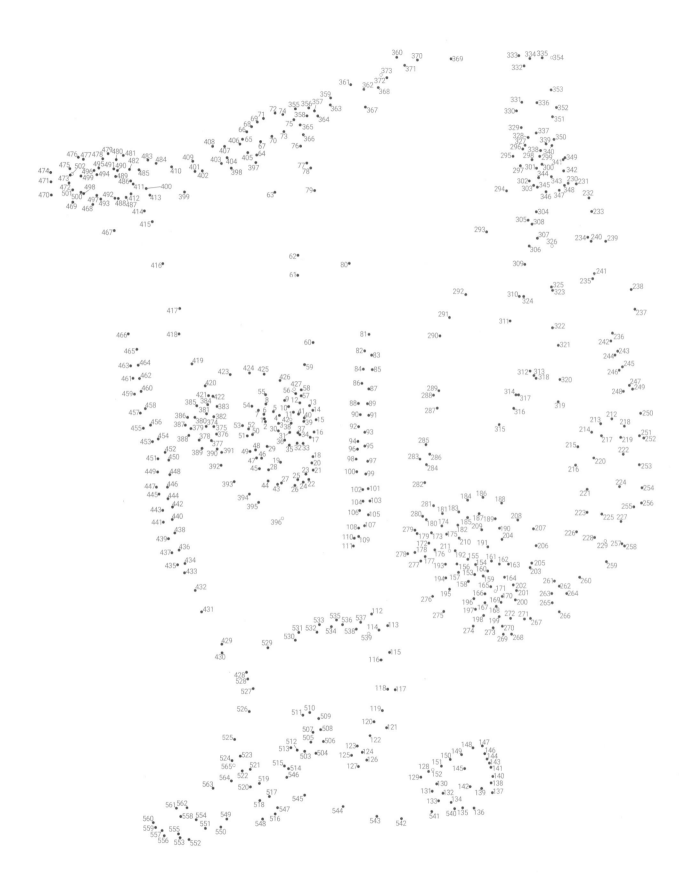

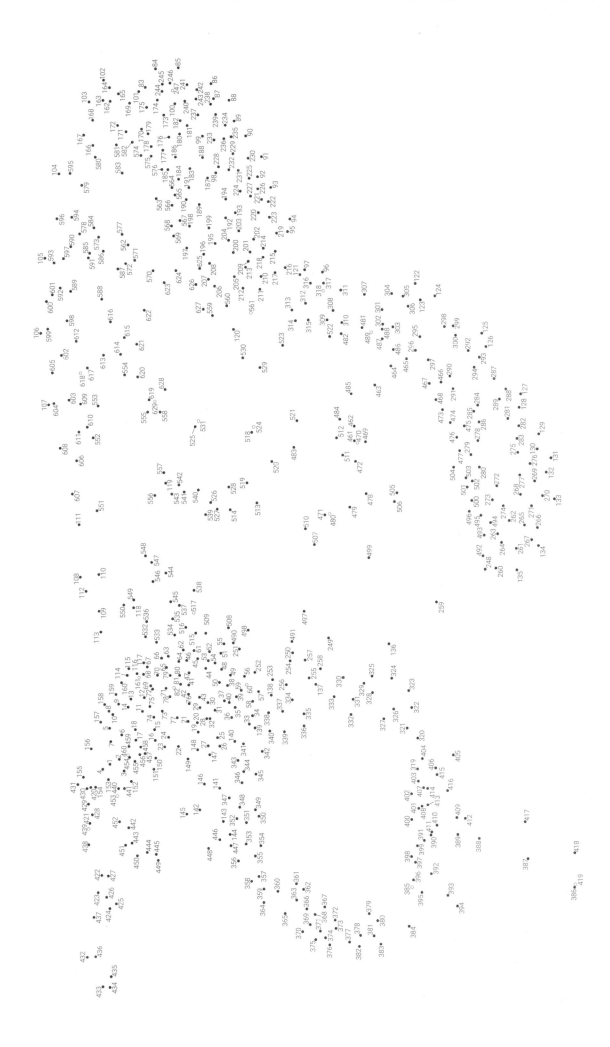

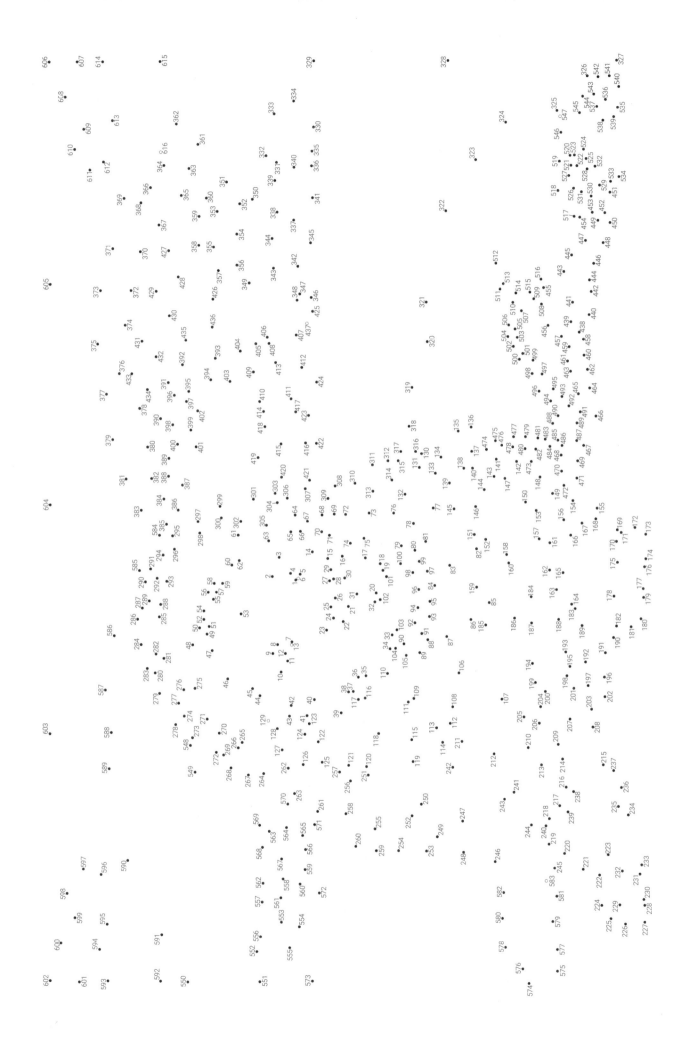

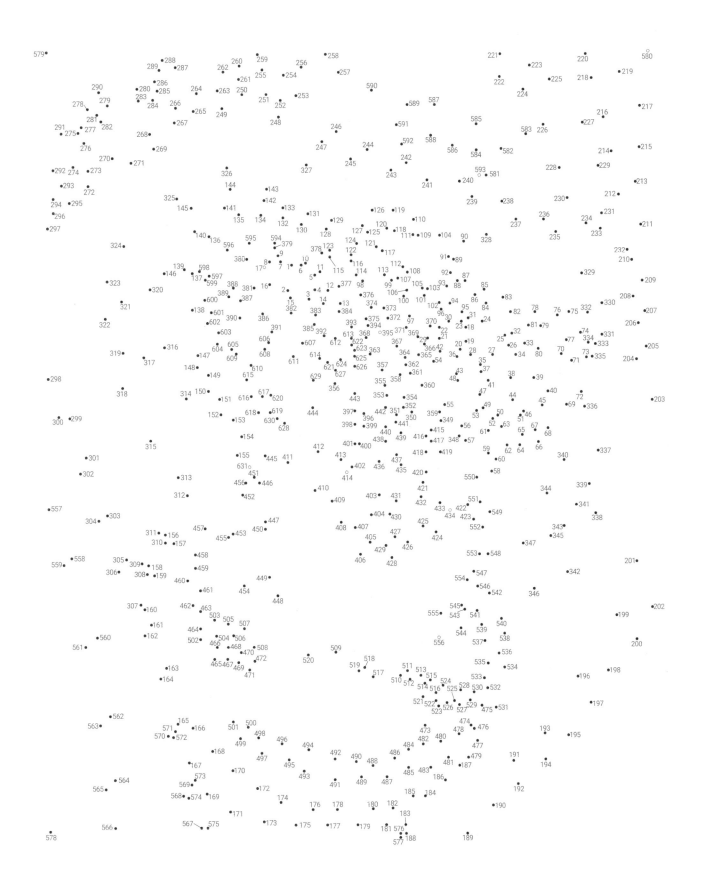

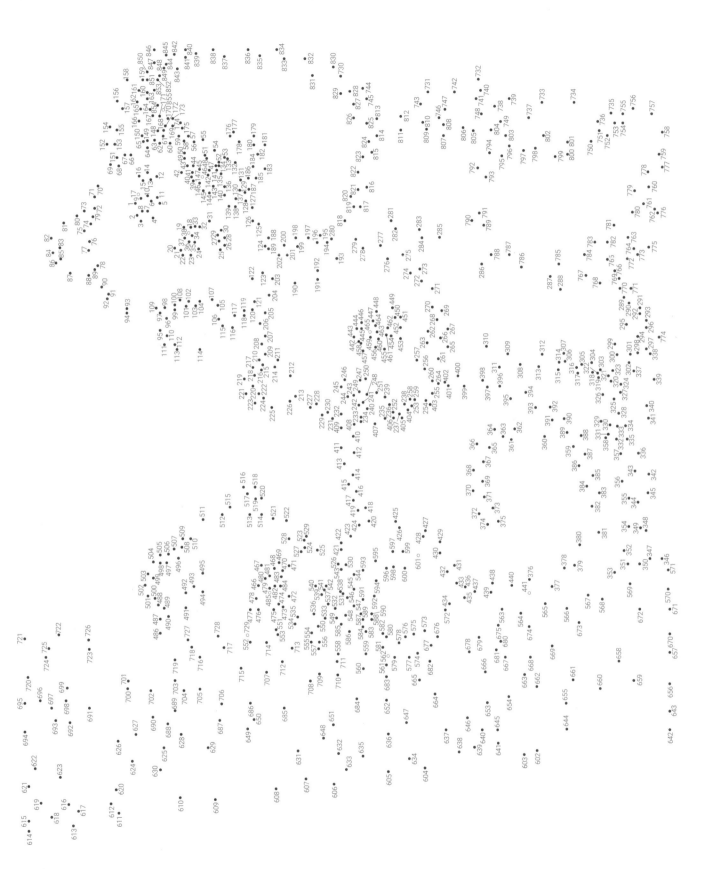

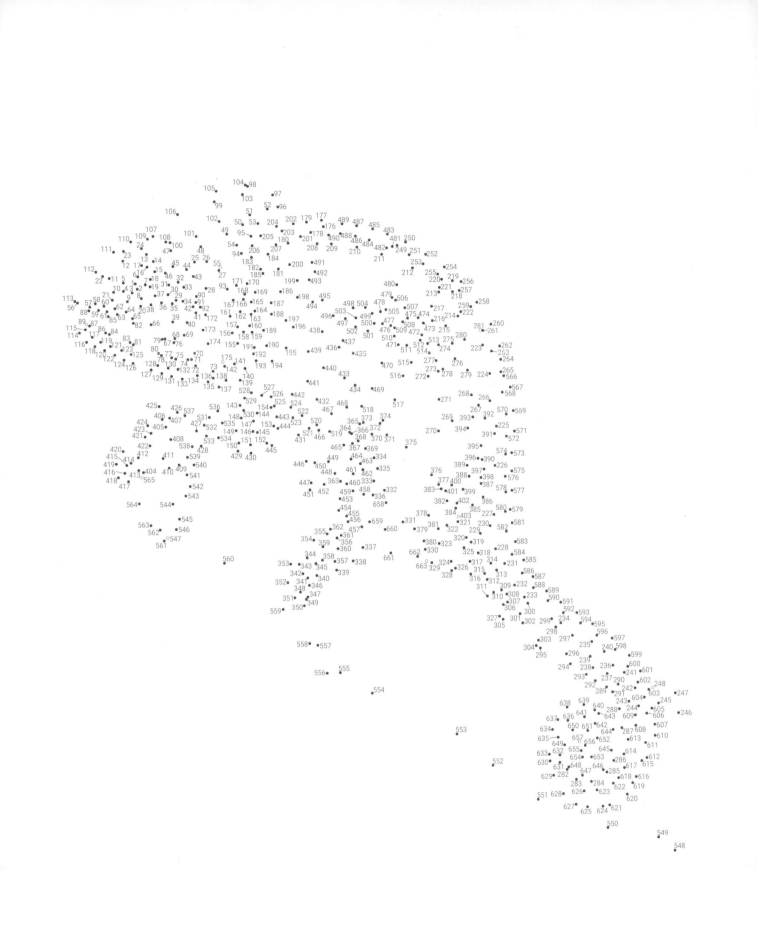

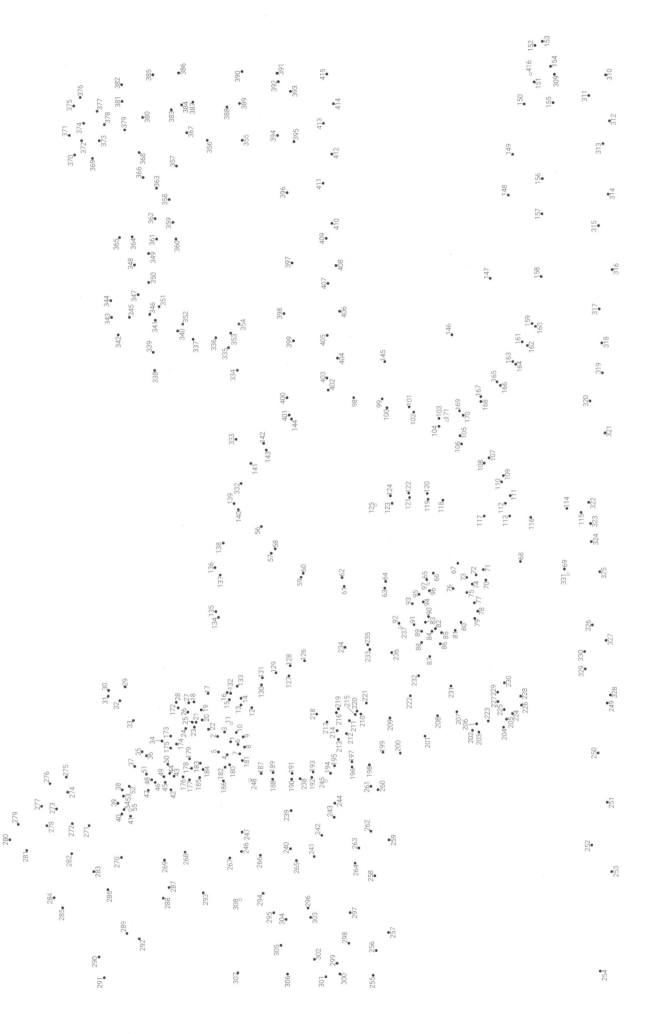

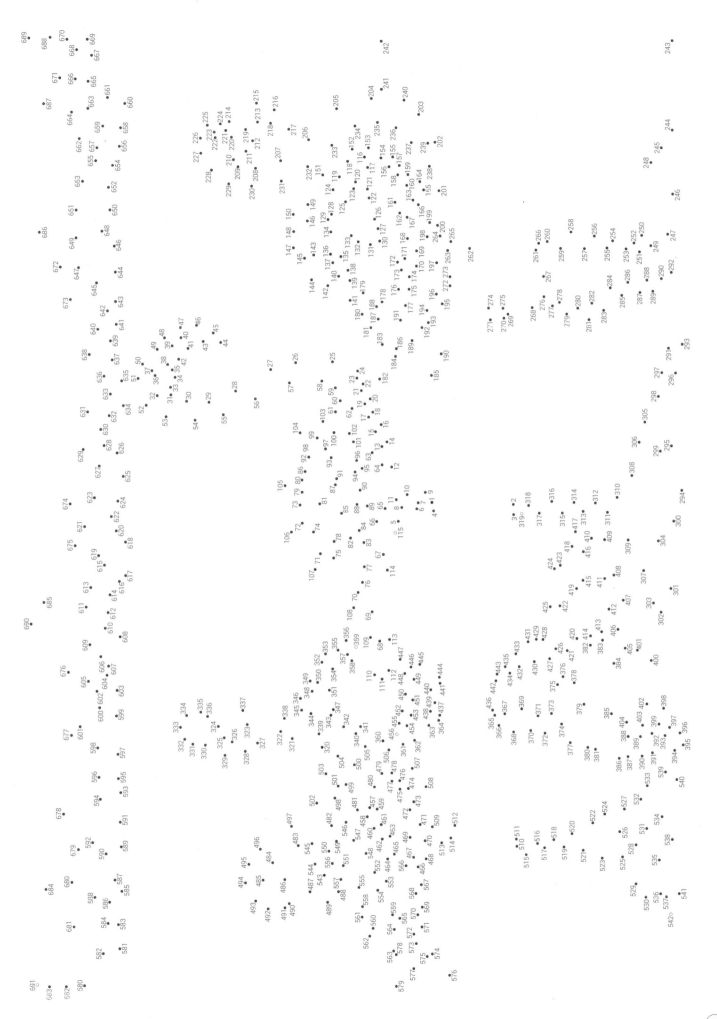

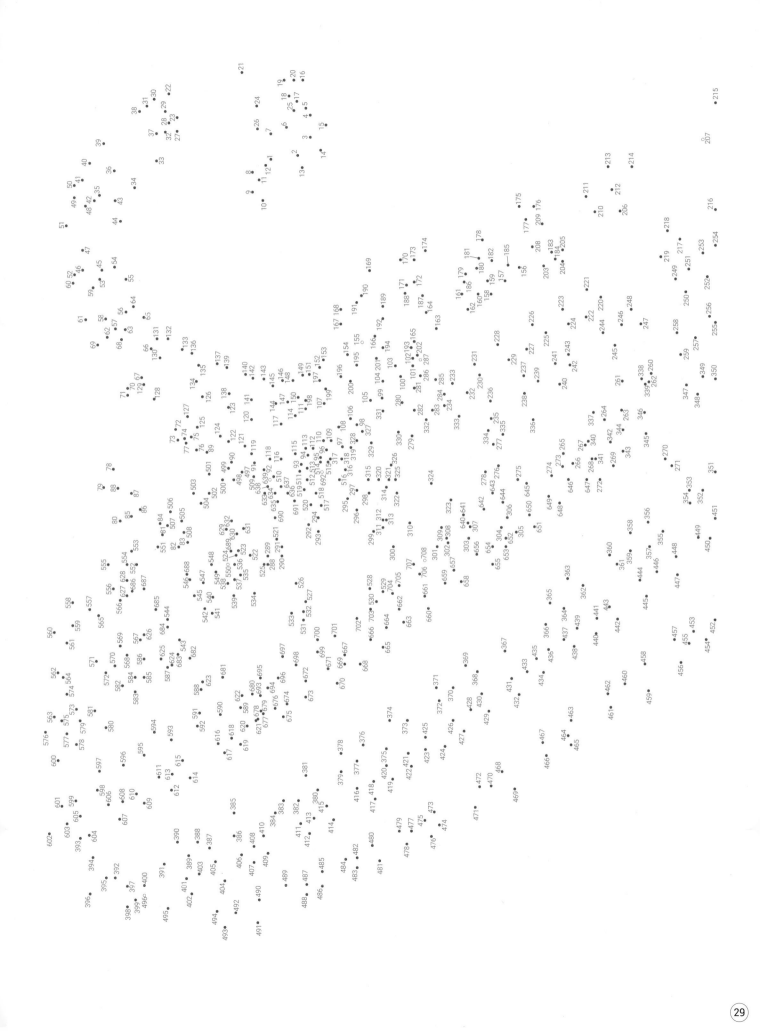

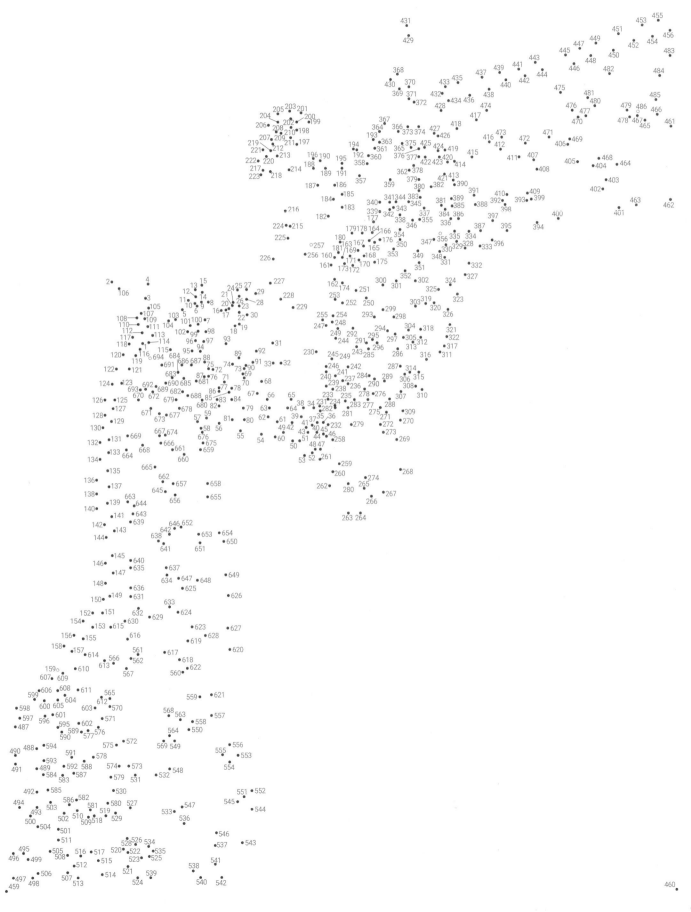

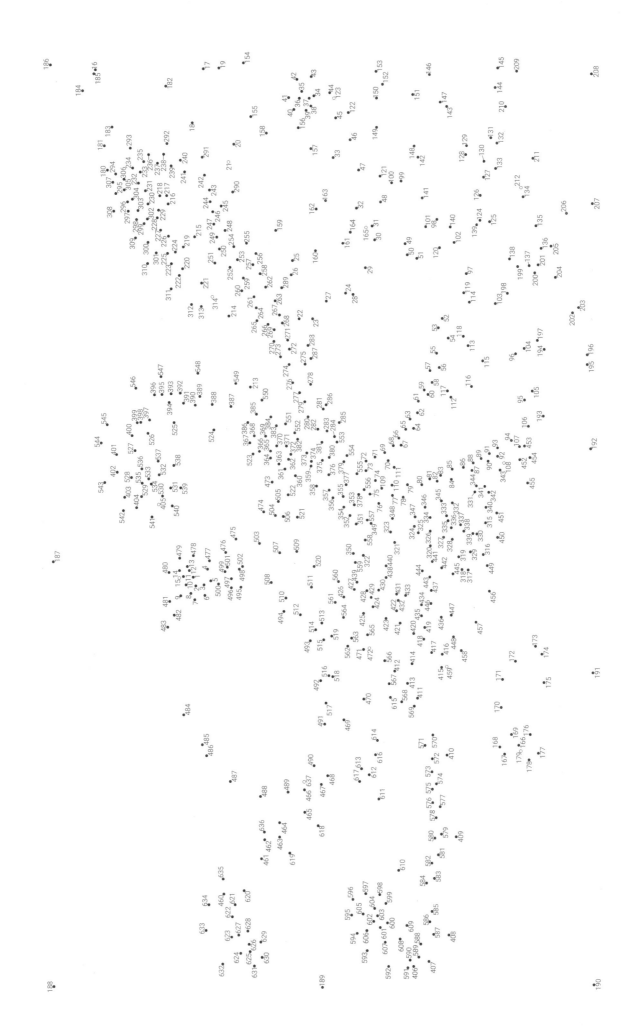

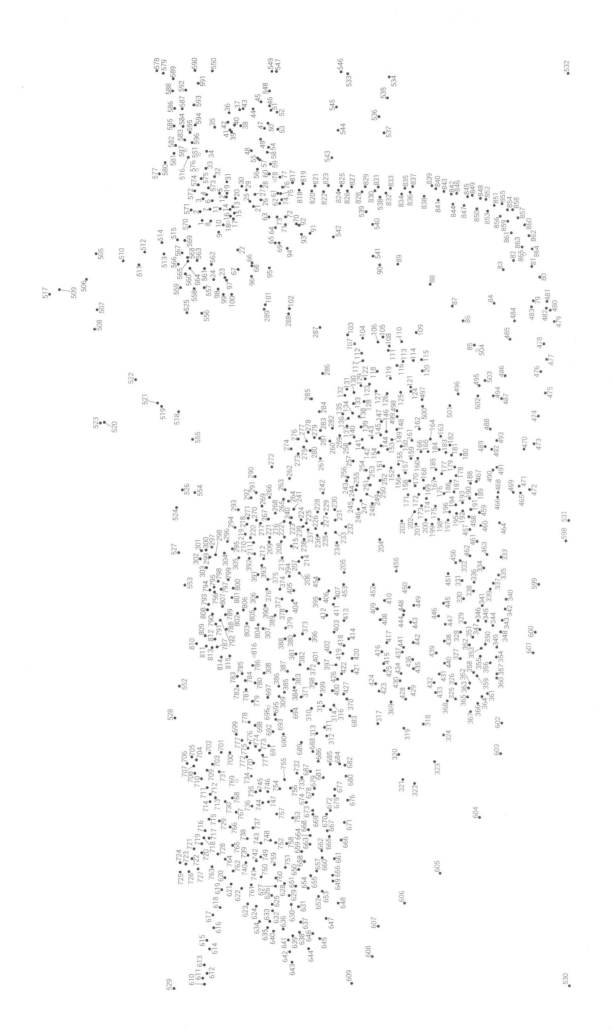

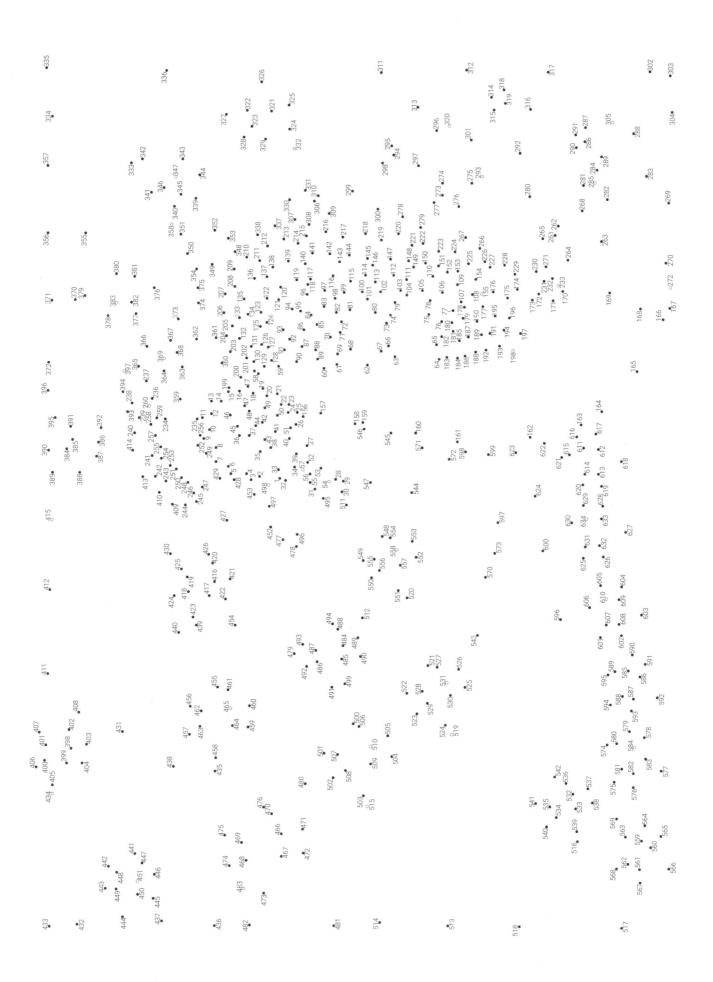

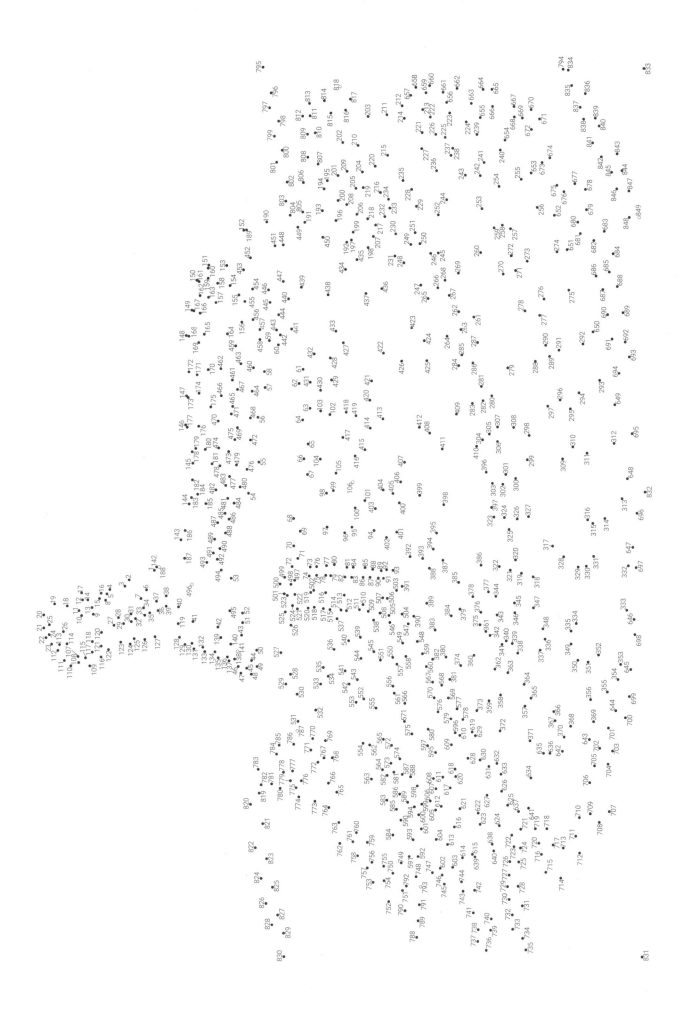

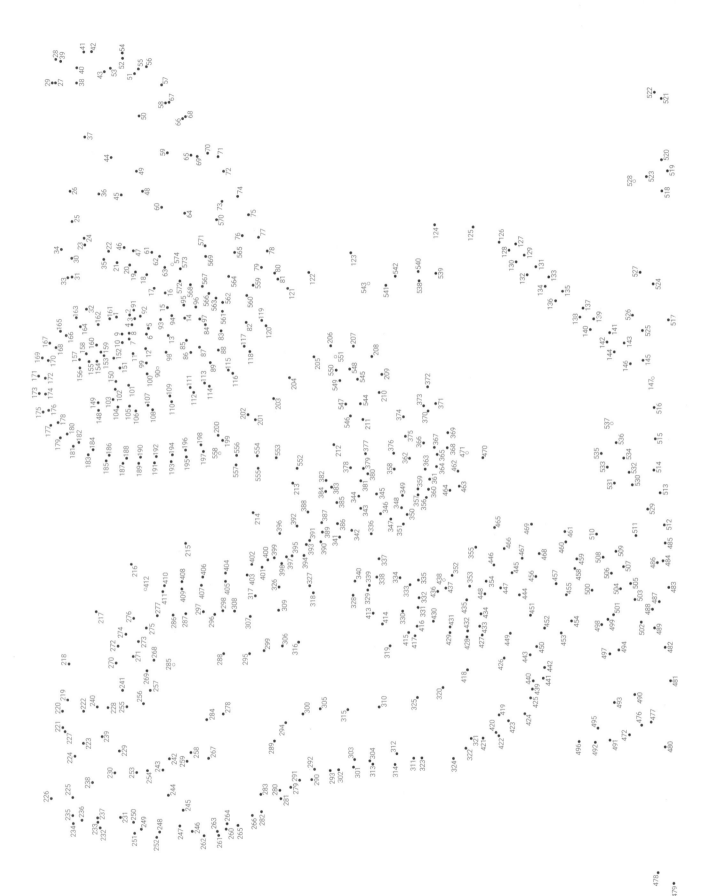

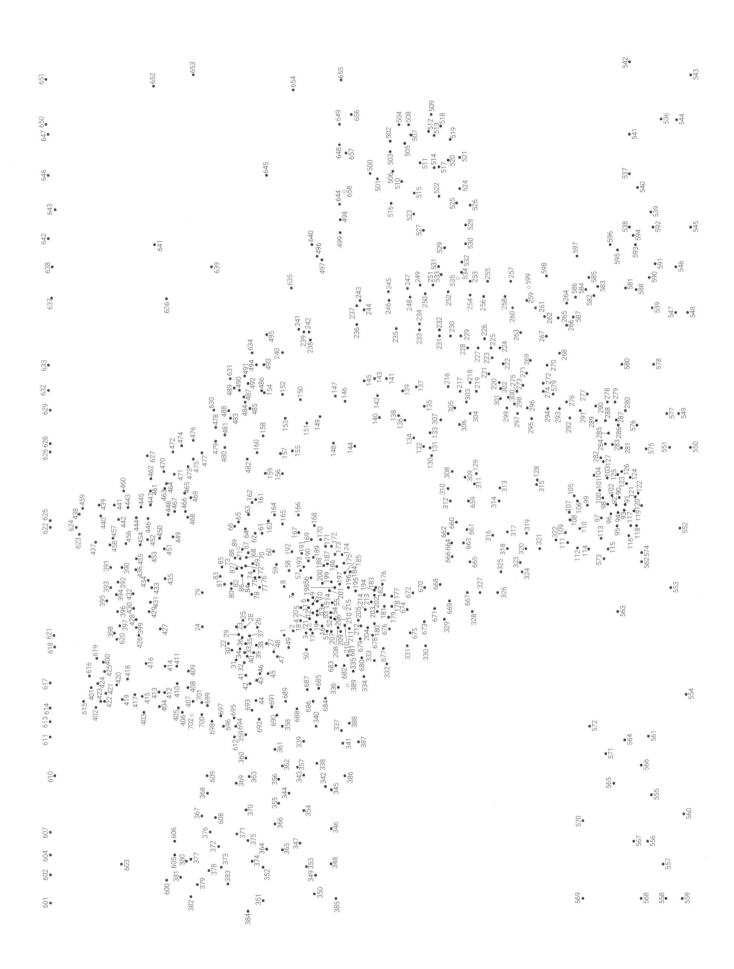

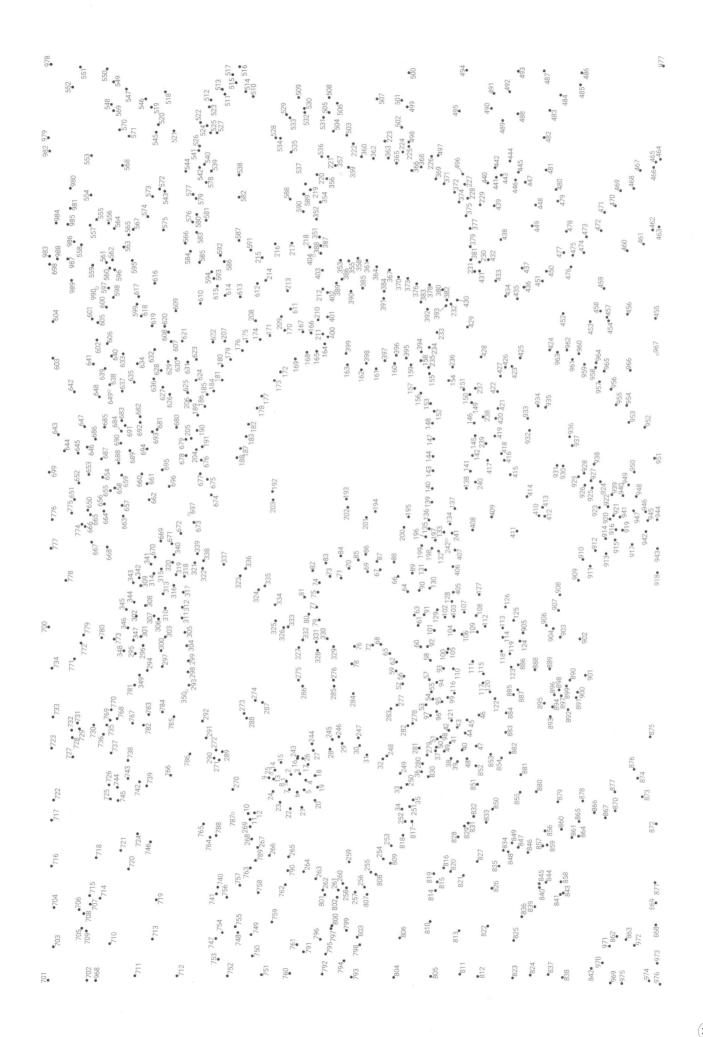

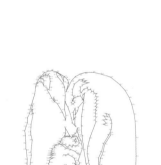

### Page 1

## Bison

The American bison, sometimes called the American buffalo, were almost wiped out by hunters in the 19th century when the vast grasslands were cleared for agriculture, and are now mainly found in reserves. They have shaggy long coats, which are darker in winter, and spend their days grazing and resting. Massive and formidable, they have a competitive attitude to mating, where the males fight for the females by ramming each other head on. **486 dots**

### Page 2

## Penguin

The black and white penguin is believed to thrive in the cold, but it is actually one of the most adaptable birds, and can be found in more temperate climates such as the south coasts of Australia and New Zealand. They use their wings as flippers to steer themselves underwater when feeding, and can leap onto land with some force if danger arises. **503 dots**

### Page 3

## Green Tree Frog

When approached by a predator the well-disguised green tree frog will quickly open its bright red eyes and stare, giving itself a chance to flee in the moment of confusion. Tree frogs lay their eggs on trees above water for the tadpoles to fall into, but they never return to the ground in their adult lives, instead living an arboreal life clinging to tree branches on their fingers and toes. **399 dots**

### Page 4

## Dolphin

Marine dolphins can be found all over the world, tending to move in groups of ten to warm tropical waters in the winter and back to the Arctic poles during the hotter summer months. They are often seen leaping out of the water as they play with each other, and in areas of ocean with plenty of food, schools of dolphins congregate in their thousands. Dolphins produce clicking noises to bounce off objects in the water as a way of hunting prey. **352 dots**

### Page 5

## Owl

The serious, wide-eyed demeanour of owls has made them considered wise in some cultures – and stupid in others (notably India). The tawny owl is a nocturnal creature who lives inside hollow nesting cavities in woodland trees. Owls are fiercely protective of their young, who are unable to fly when they first leave the nest, and so they will also hunt in the day for their chicks. **452 dots**

### Page 6

## Zebra

The distinct black and white stripes on the zebra allow it to blend into the natural patterns of light and shade on the African plains when running in a herd away from a predator. When young male groups reach maturity they leave their family groups to live with other bachelors. Zebras may fight each other over females, but they can also be affectionate and spend a lot of time grooming each other. **574 dots**

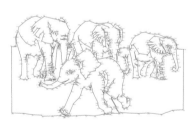

### Page 7

## African Elephant

The African savannah elephant is the world's largest living land animal and is distinctive for its large ears and long trunk, used for feeding, fighting and communication. The oldest and largest female elephant always leads the group, and drives away the young males at puberty. Males compete to mate in aggressive displays of fighting, which can sometimes lead to fatal injuries. **754 dots**

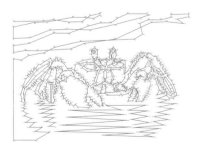

### Page 8

## Crab

Famed for their sideways scuttling walk on land, some crab species also have specially adapted limbs that allow them to swim backwards. Their broad, flat shells and powerful pincers make them formidable opponents to both predators and prey. Crabs often release pheromones to attract a mate, and the male velvet crab may cling onto the female for several days during the mating period. **737 dots**

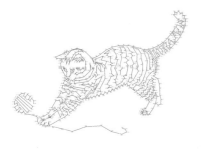

**Page 9**

## Cat

The domesticated cat is one of the most loved animals worldwide. For thousands of years humans have kept cats in their homes, valuing their companionship and useful vermin-hunting skills. Although cats can be sociable and treat humans as no different from themselves, they are also potent hunters and it is estimated they are responsible for the extinction of 33 bird species. **634 dots**

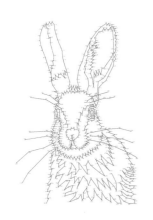

**Page 10**

## Hare

The hare's speed is no myth: it is able to reach speeds of 60kph/37mph and make sharp, evasive turns when running away from a predator. Hares spend most of the day sleeping, coming out at night on their own to feed. To avoid predators the female hare hides her young leverets in specially dug holes, visiting them one by one to nurse them. **676 dots**

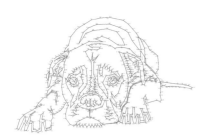

**Page 11**

## Dog

The dog has been 'man's best friend' for tens of thousands of years, with the various modern breeds descending from a wolf-like canid in Eurasia 40,000 years ago. Their loyalty to humans is displayed in their many roles, including hunting, protection, and pulling loads. Their intense attachments to people has allowed their species to prosper over the years. **679 dots**

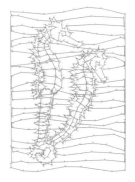

**Page 12**

## Seahorse

So-named due to the distinctive shape of their head, seahorses are in fact fish, despite the unusual way they float upright in the water. Found in the Mediterranean and Great Britain, seahorses may be common but their mating practice is anything but: the male and female perform an elaborate courtship dance by linking their tails together before the female transfers her eggs to the male's pouch to later give birth. **640 dots**

### Page 13

## Armadillo

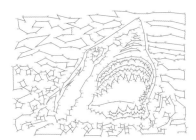

The leathery shell on the armadillo allows it to curl up into a protective ball when cornered by predators. Armadillos use their long noses as a poking device to search out their animal prey in stone crevices and under logs. When not mating, armadillos normally keep the company of their own sex, and when the female gives birth in the spring it is to litters of identical same-sex quadruplets. **641 dots**

### Page 14

## Shark

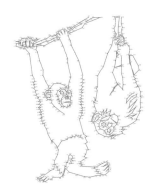

Popular culture including the film 'Jaws' has established the shark as a deadly, ruthless killer. Although the notorious great white shark has a reputation for attacking humans by lunging up from below and delivering lightning-fast bites, in such cases it has usually mistaken its prey for its more natural food of seals or turtles. Sharks can also detect one drop of blood in a million drops of water – or from 400m/1312ft away. **729 dots**

### Page 15

## Chimpanzee

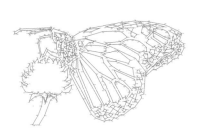

Sharing 98% of human DNA, chimpanzees are intelligent creatures able to communicate with vocalizations and facial expressions. They can also use tools to undertake tasks, such as poking a twig into a termite's nest to extract the insects. However, they are also aggressive, territorial creatures, and like humans they will go to war or hunt and kill members of another group. **565 dots**

### Page 16

## Butterfly

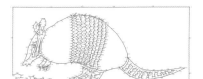

With their bright wings and conspicuous, fluttering flight, butterflies can be some of the prettiest creatures in the animal kingdom, but many species are in serious danger from environmental factors. They are most famed for their distinctive metamorphosis cycle, where the caterpillar emerges from an egg, loses its skin several times, then hangs upside down from a tree inside a chrysalis for three to five days when it finally emerges as a butterfly. **629 dots**

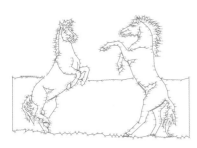

**Page 17**

## Horse

The horse has been domesticated by humans for over 6,000 years, and has been invaluable for transport, battle, agriculture and sport. Although domesticated horses are generally well looked after with food and shelter, they have retained their strong fight or flight instinct. One of the results of this is an unusual ability for horses to sleep both lying down and standing up. **648 dots**

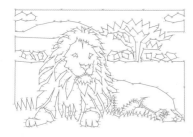

**Page 18**

## Lion

Although the male lion's thick mane is a symbol of its dominance, it is the female who does most of the hunting. The male simply helps himself to the female's kills, and sleeps much of the day. A pride – or a group of lions – usually has around ten females and their cubs, with just one or two males. A dominant male only has around three years before he is usurped by a younger contender. **616 dots**

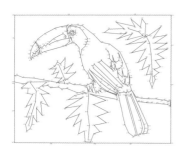

**Page 19**

## Toucan

Members of the toucan family are unmistakeable for their large, bright bills. Although it is a bit of a mystery why they have them, it is believed the bills help them to pluck fruit from branches that would otherwise be out of reach. The toucan's habitat ranges from forest to savannah in South America, and they sometimes nest in tree hollows previously occupied by woodpeckers. **378 dots**

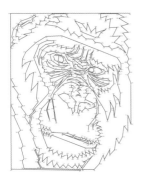

**Page 20**

## Gorilla

The lowland gorilla may be on the endangered species, but its cousin, the mountain gorilla, is down to the last 600 existing in the wild. Poaching and animal trapping has heavily reduced the numbers of this powerful, yet gentle creature. Gorillas tend to live in groups of about six, led by the dominant silverback male who may stand up and beat his chest to scare off intruders. **631 dots**

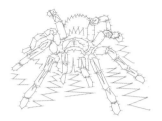

**Page 21**

## Spider

The fear of spiders is called arachnophobia, and this may be an evolutionary trait to protect humans from their venom, and not just because of their scuttling eight-legged walk. Spiders are one of the most diverse animals on the planet, with over 45,000 different species existing in every continent except Antarctica. Most spiders have short lifespans, but the tarantula can live up to 25 years old in captivity. **499 dots**

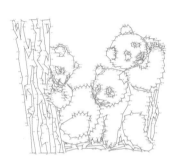

**Page 22**

## Giant Panda

Native to China, the giant panda is one of the most loved animals around the world, but it is also one of the most endangered, with around 2,000 left. This is partly down to a loss of interest in mating in captive pandas, and a tiny breeding window of 2−3 days once a year. The panda has a limited diet and eats almost exclusively bamboo. **855 dots**

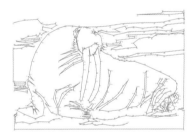

**Page 23**

## Walrus

Walruses use their long tusks to fight enemies, pull themselves up to floating ice or hook themselves to floes so they can sleep in the water. The male walrus is twice the size of the female, and has two air pouches in his neck to amplify his mating calls. Walruses live in herds of up to several thousand, feeding through thin ice in the winter and moving to land in the summer. **523 dots**

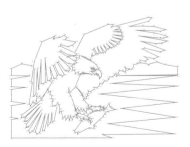

**Page 24**

## Golden Eagle

The majestic golden eagle has been regarded as almost mythical in some ancient cultures for its supreme hunting prowess. Some eagles are capable of killing wolves, while others kill tortoises by dropping them from a great height to break their shell. Eagles take up nest in high, remote areas (such as wild mountain ranges) and often return there for several years to mate. **382 dots**

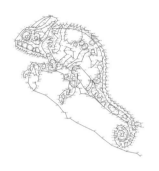

**Page 25**

## Chameleon

Chameleons are famous for their ability to change colour and blend into the background. They can camouflage themselves when moving to different vegetation, and they also use it as a form of communication with other chameleons, for instance warning them to keep away. Chameleons are also notable for their long, lightning-fast tongues with which they catch prey. **663 dots**

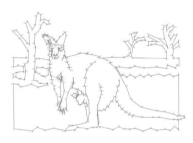

**Page 26**

## Kangaroo

Famous for holding their young in a pouch, kangaroos are the most well-known member of the marsupial family. Found all around Australia, the kangaroo can cover large areas of ground by leaping off its back legs at 9m/29.5ft at a time. Male kangaroos will fight each other for water or for the females through a form of 'boxing,' where they stand upright and paw at each other. **416 dots**

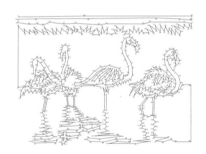

**Page 27**

## Flamingo

The flamingo gets its pinkish hue from its diet of algae or of small creatures that have eaten the microscopic plants. They feed by walking along with their heads submerged and sweeping their long neck from side to side. Found in Central and South America, they can live for up to 30 years in the wild, but are vulnerable to habitat loss or pollution of the coastal lagoons they inhabit. **691 dots**

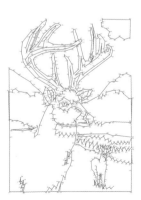

**Page 28**

## Highland Deer

The beautiful red deer are native to northern Europe and Britain but particularly widespread in Scotland, and can be seen wild and reared in open hills and woodland, and in ornamental deer parks. The majestic antlered males – also called stags or harts – attempt to attract females with dance-like rituals and bellowing, an impressive wildlife spectacle called the autumn rut. **650 dots**

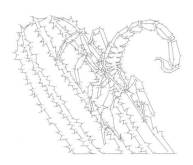

**Page 29**

## Scorpion

With its eight legs, pair of pincers and curved sting tail, the scorpion appears to be one of the most threatening creatures alive. Indeed, some scorpions do possess enough venom to kill a human being – but the chances are small with only 25 out of 1750 species being deadly. Scorpions can adapt to all conditions and have colonized the whole planet with the exception of Antarctica. **708 dots**

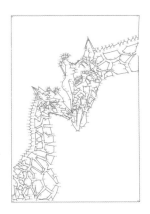

**Page 30**

## Giraffe

The long neck of the giraffe makes it the tallest animal in the world – and is a useful tool for reaching high leaves, spotting danger from afar or even swinging its head to ward off attackers. It's long neck does mean that it has to splay its front legs apart to reach fresh grass or drinking water, and when giraffes sleep they coil their necks and rest them on their hindquarters. **694 dots**

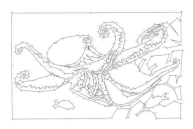

**Page 31**

## Octopus

The eight-legged octopus is one of the most common marine creatures, distributed in most temperate and tropical oceans. Its menacing reputation is not without reason: the octopus lurks in holes and under ledges waiting for its prey, then captures it at night with its long, suckered arms. Scientific experiments have shown the octopus can learn simple tasks and undertake problem solving. **637 dots**

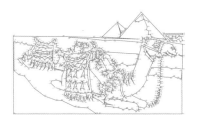

**Page 32**

## Camel

The one-humped camel (dromedary), can be found around the horn of Africa and the Middle East, with the other surviving species, the two-humped camel (bactrian), inhabiting Central Asia. They have been domesticated for more than 4,000 years and can carry loads of 200kg/2.2 tons for several days. Their humps are filled with fat and provide an energy reserve, and they can go for long periods without drinking water. **865 dots**

**Page 33**

## Mouse

Once worshipped by the Romans and ancient Greeks, mice are now considered major pests for damaging food and property, and carrying disease. However, they are virtually unrivalled in their ability to adapt to new surroundings: by staying near humans and stowing away on ships and aeroplanes they have managed to colonize every continent in the world, including Antarctica. **1020 dots**

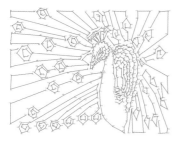

**Page 34**

## Peacock

The 'peacock' is in fact the name of the male peafowl, as the female peahen does not have the same extravagant feathers. Its large, vividly patterned tail serves multiple purposes: to attract females, deter rivals and prove their fitness (as other birds would struggle to survive with such a large feature). Peacocks also produce a distinct mating call to attract the choosy female. **634 dots**

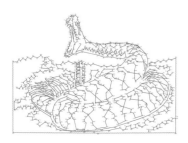

**Page 35**

## Snake

Contrary to popular belief, snakes are not slimy but rather covered in smooth, dry scales. They are unable to chew their prey so have to swallow it whole, detaching their lower jaws from their upper jaws to engulf animals bigger than their own heads. One breed feeds on large weaver bird eggs, swallowing them whole and cracking them inside with tooth-like structures near their vertebrae. **849 dots**

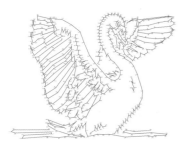

**Page 36**

## Swan

The image of two swans together with their necks intertwining to form a heart shape has become a symbol for love, as swans are one of the few animals who mate for life. Their long, slender neck, which is used to dabble under the surface of the water to obtain food, is often seen as a sign of their elegance – but swans are also very territorial and will aggressively try to drive away anyone who ventures too close. **574 dots**

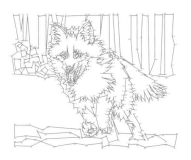

**Page 37**

Fox

Able to colonize almost any habitat and even survive on human food waste, it is no surprise that the red fox is widespread across the entire Northern Hemisphere. With a reputation for being cunning, foxes leave their scent to mark territories and breed between 3-12 pups every spring, depending on food availability. Foxes also like to curl up and sunbathe by railway lines and roadsides. **702 dots**

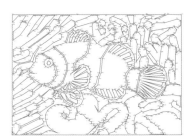

**Page 38**

Clownfish

Perhaps best associated with the film 'Finding Nemo', the clownfish is a tropical reef fish found around the Pacific Islands. Its protective coating of mucus allows it to shelter within the stinging tentacles of large sea anemones as a defence against other fish. If the large female fish in a group dies, the breeding male changes sex to take over as egg-layer, while a younger male fish is promoted to breeding male. **990 dots**

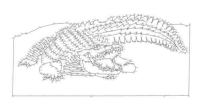

**Page 39**

Crocodile

With their thick, scaly skin, powerful jaws, and respiratory system that allows them to hide underwater for hours at a time, crocodiles are fierce predators – and this winning formula has hardly changed since the age of the dinosaur. Female dwarf crocodiles were once considered cannibals because they carry their young in their mouths, but this is actually a gentle method of transporting them. **768 dots**

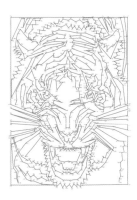

**Page 40**

Tiger

Poaching, logging and deforestation across much of Asia has left the orange- and black-striped tiger in a critically endangered state, having lost 93% of their historic range over the last 100 years. Tigers tend to keep to themselves (or with their cubs for the first two years) and mark their territories to avoid accidental meetings and disputes. Although they are slower than other cats, their strong hind legs can propel them forward at leaps of up to 10m/33ft. **879 dots**

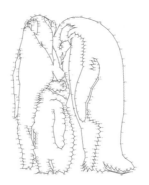

This edition published by Southwater, an imprint of Anness Publishing Ltd,
108 Great Russell Street, London WC1B 3NA
info@anness.com; www.annesspublishing.com
twitter@Anness_Books

Publisher: Joanna Lorenz
Editorial Director: Helen Sudell
Editorial Assistant: Matt Bugler
Illustrations by Jeni Child

A CIP catalogue record for this book is available from the British Library.

Publisher's Note
Although the information in this book is believed to be accurate and true at the time of going
to press neither the author nor the publisher can accept any legal responsibility or liability for
any errors or omissions that may have been made.